"ONE CAT JUST LEADS TO ANOTHER."

ERNEST HEMINGWAY

D1531464

INSTA GRAMMAR
CATS

LANNOO

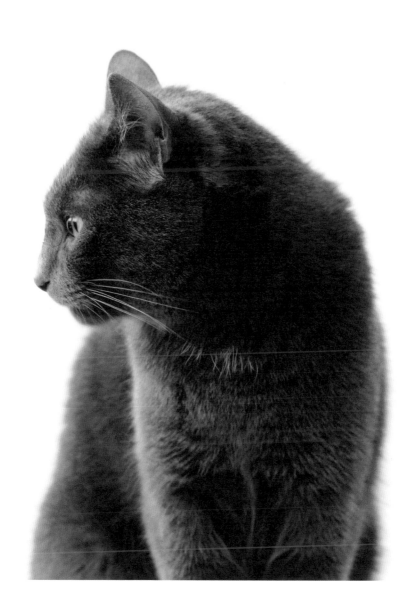

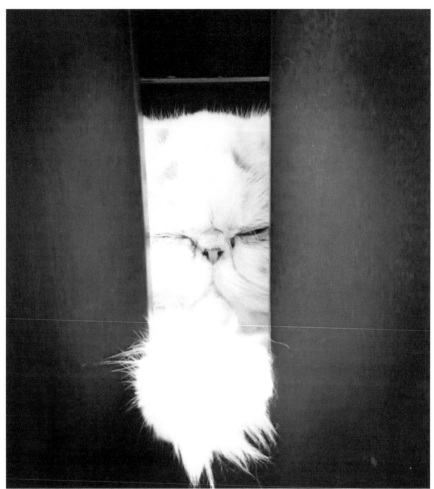

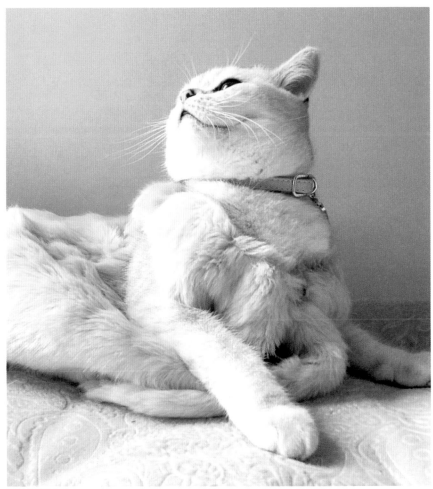

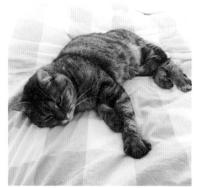

@HANNEMANS

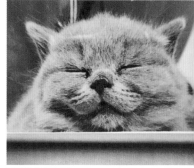

@DEWERELDVANSOPHIE

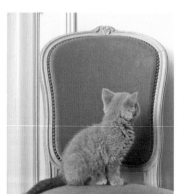

@PATRICIAGOUENS

@DEWERELDVANSOPHIE

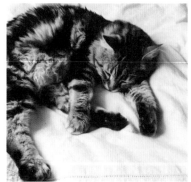

@SILVERSPIES

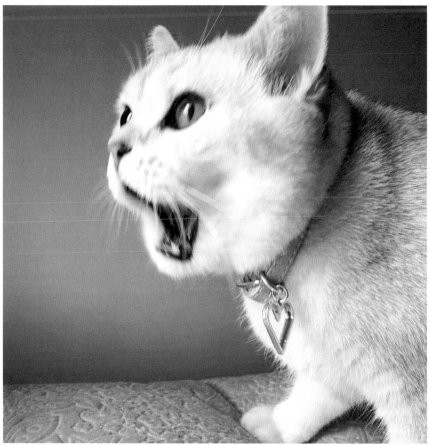

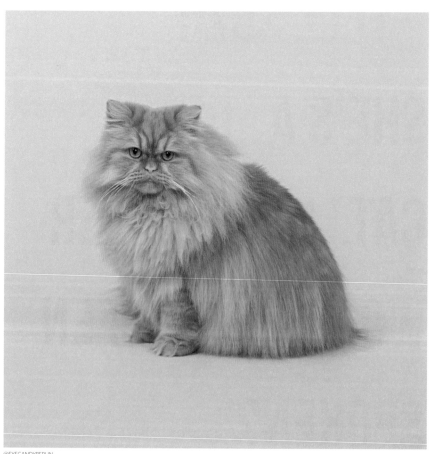

"'TELL SUZIE SHE'S A LUCKY CAT.' HAVE SEXIER WORDS EVER BEEN SPOKEN?"

ALLY CARTER

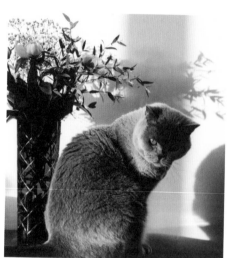

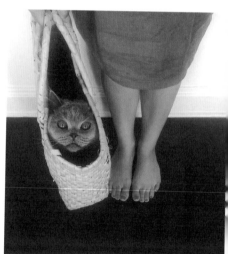

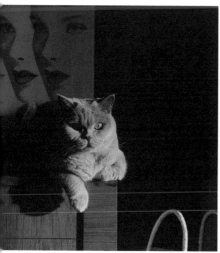

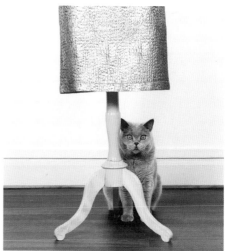

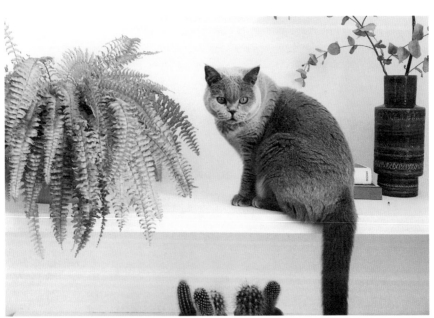

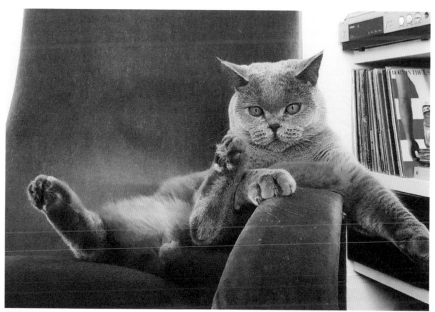

"CATS ARE CONNOISSEURS

JAMES HERRIOT

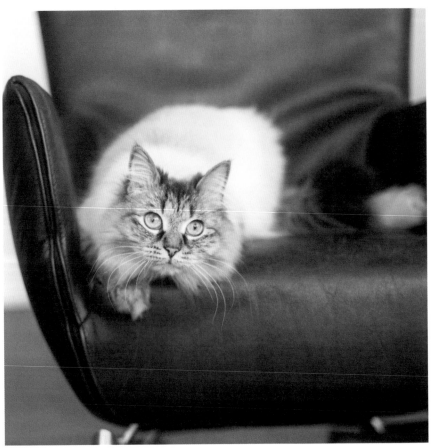

OF COMFORT."

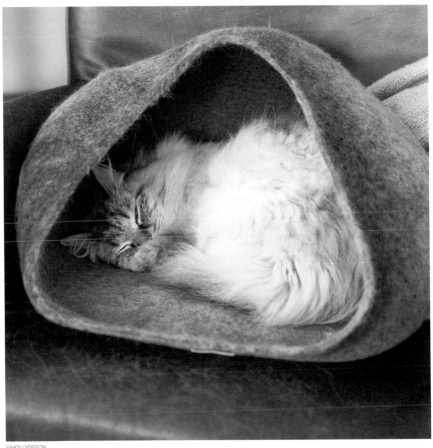

@HOLLYSISSON

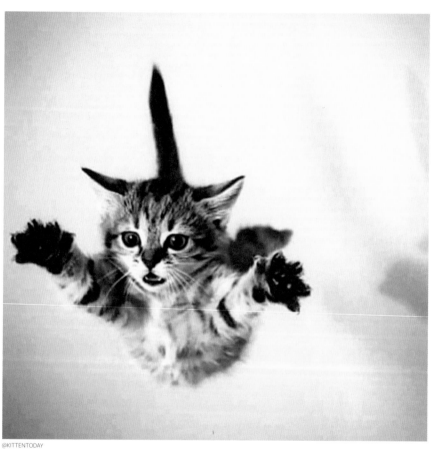

@KITTENTODAY

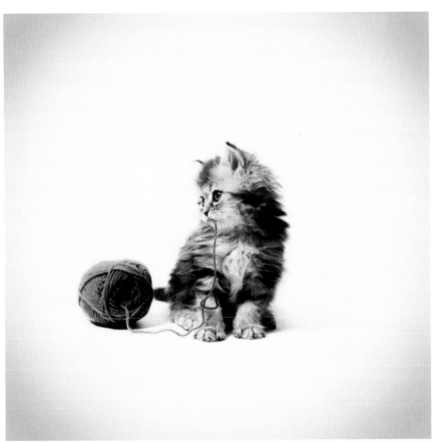

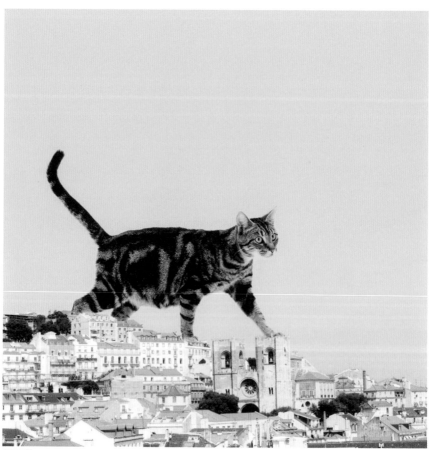
@HEYLUISA

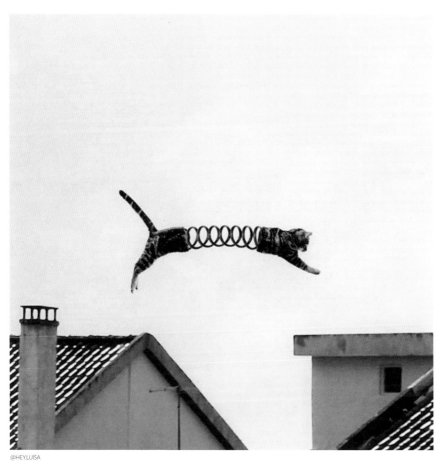

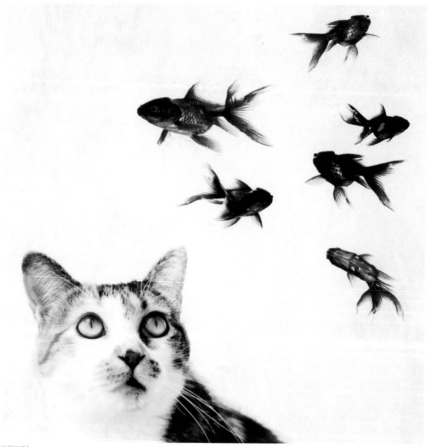

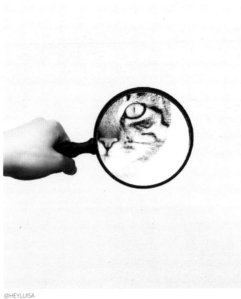

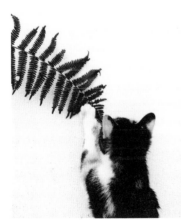

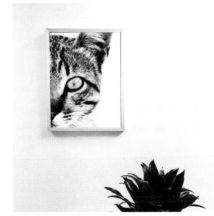

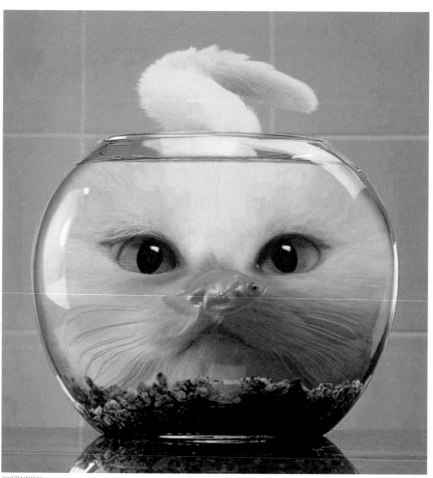

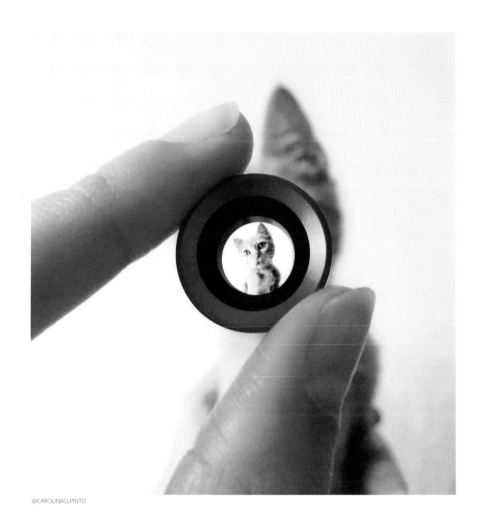

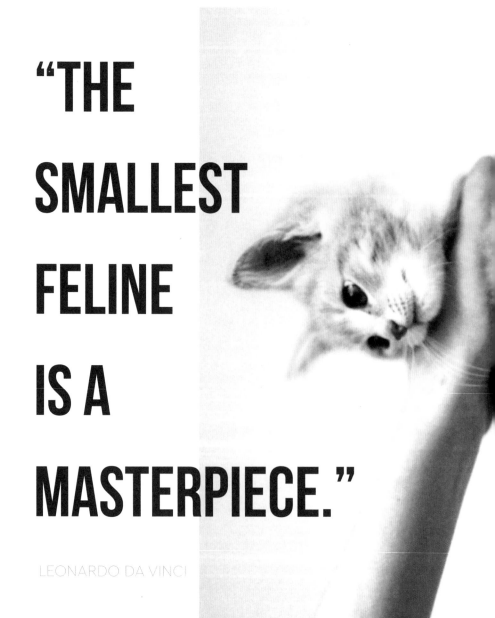

"THE SMALLEST FELINE IS A MASTERPIECE."

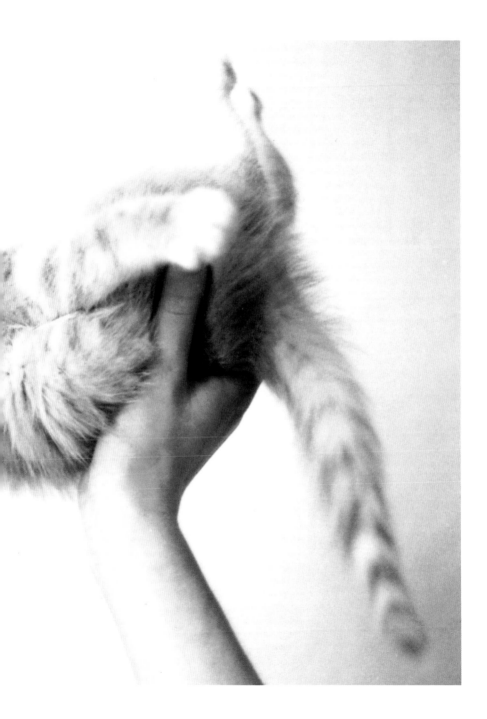

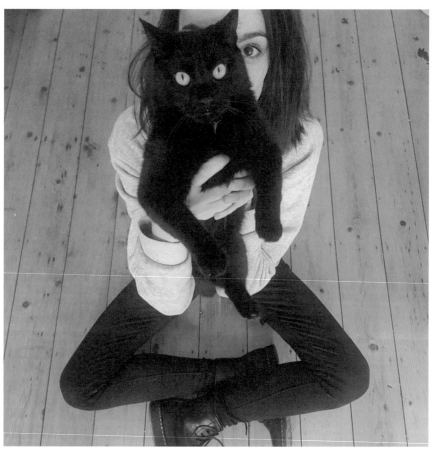

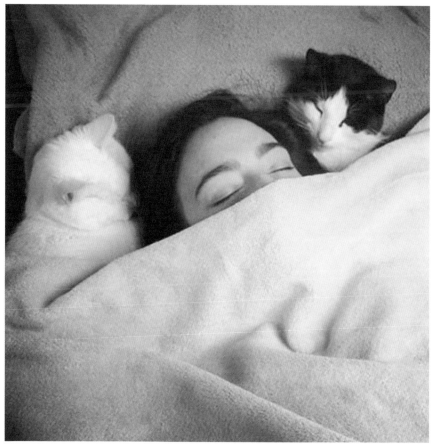

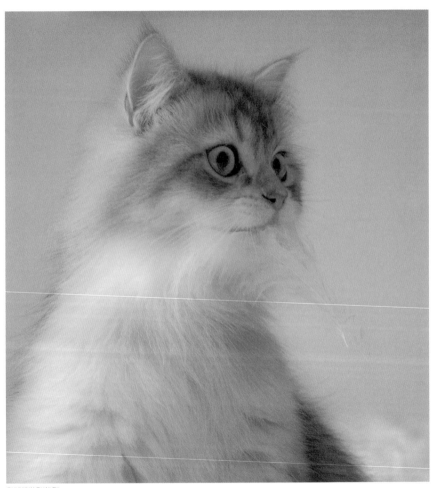

@HUNKYANDHAILEY

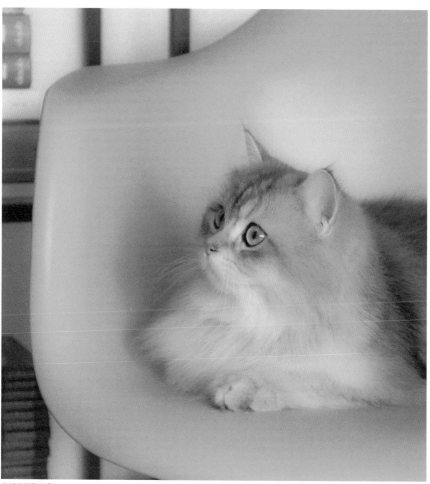

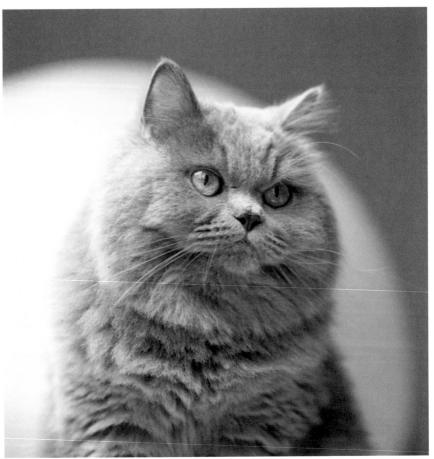

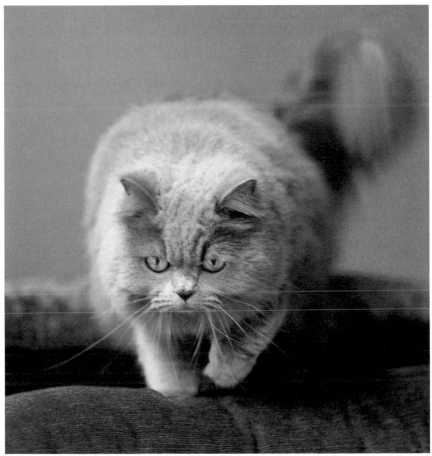

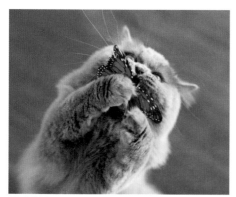
@PANTHER.CAT

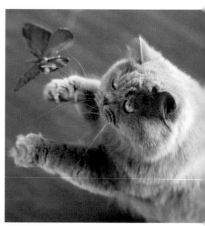
@PANTHER.CAT

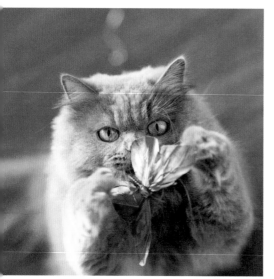
@PANTHER.CAT

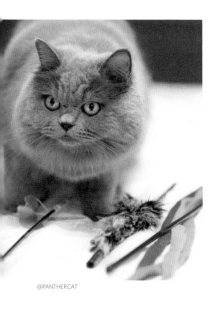

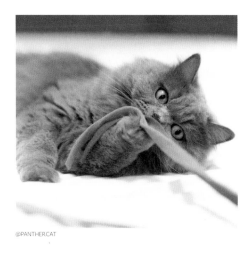

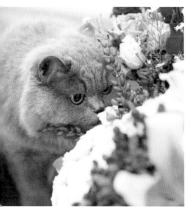

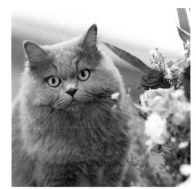

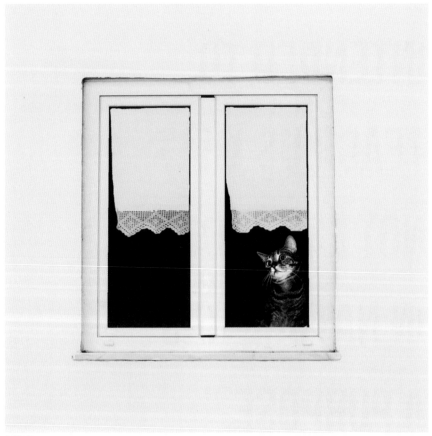

"CATS ARE INTENDED TO TEACH US THAT NOT EVERYTHING IN NATURE HAS A PURPOSE."

GARRISON KEILLOR

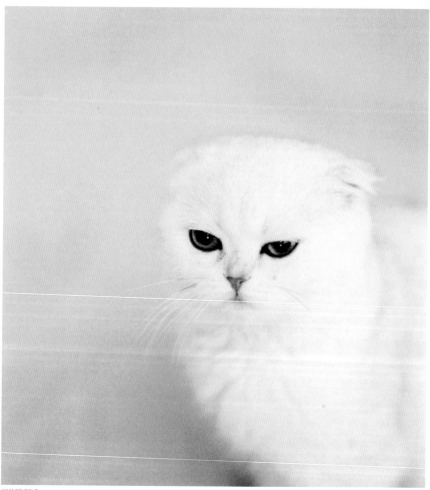

@MAISEYFOLD

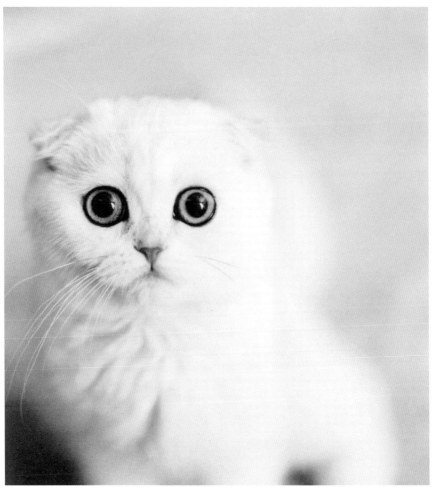

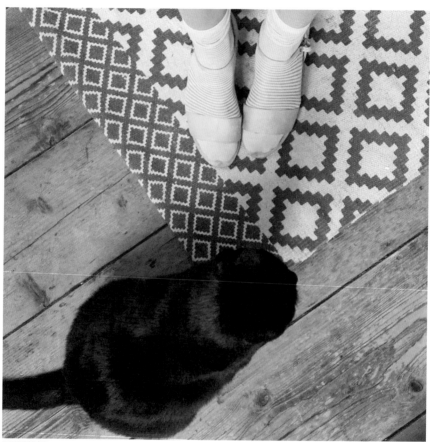

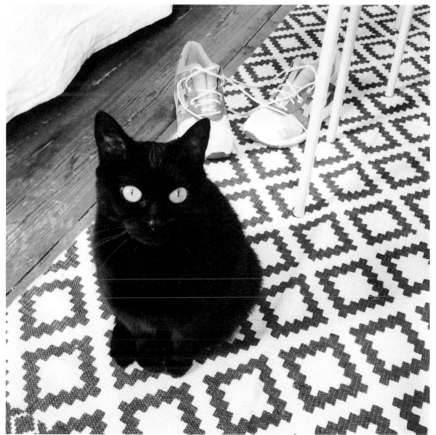

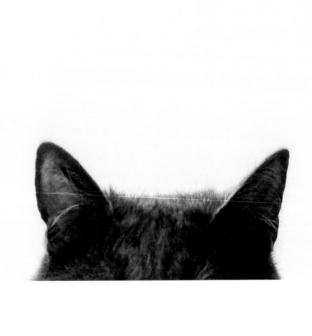

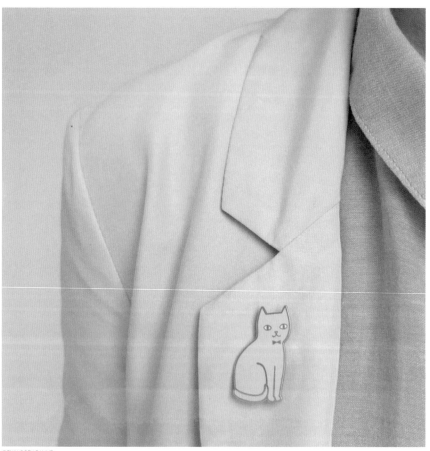

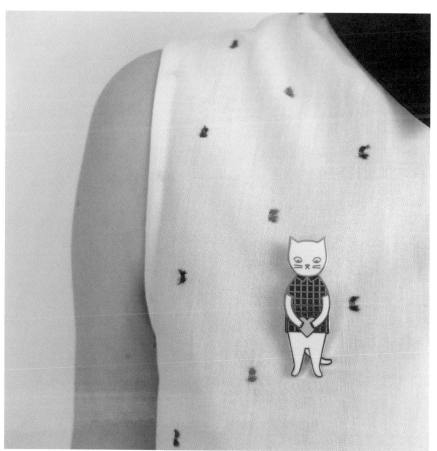

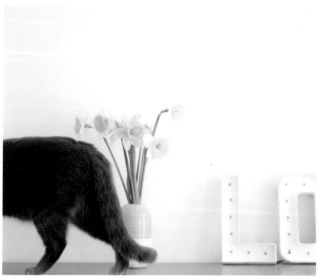

@CARNETDEPRINTEMPS

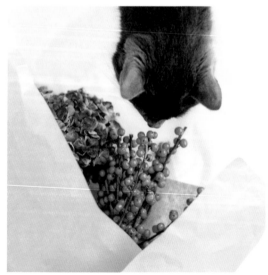

@CARNETDEPRINTEMPS

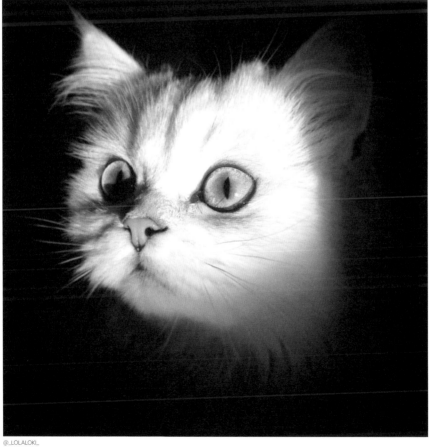

"THERE ARE TWO MEANS OF REFUGE FROM THE MISERY OF LIFE. MUSIC AND CATS."

ALBERT SCHWEITZER

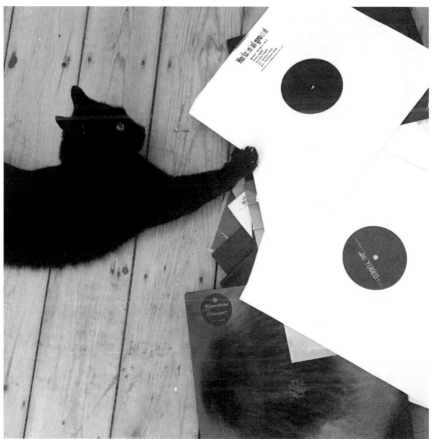

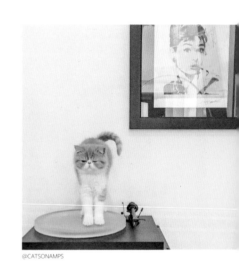

@CATSONAMPS

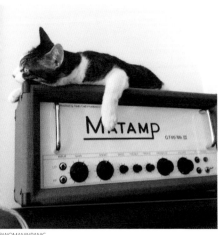

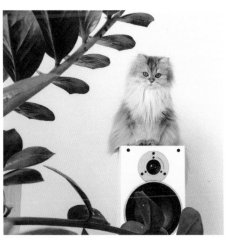

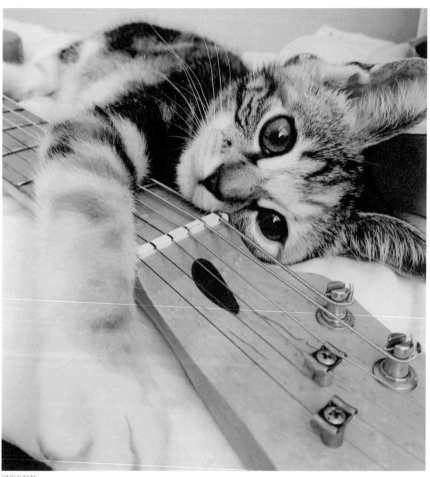

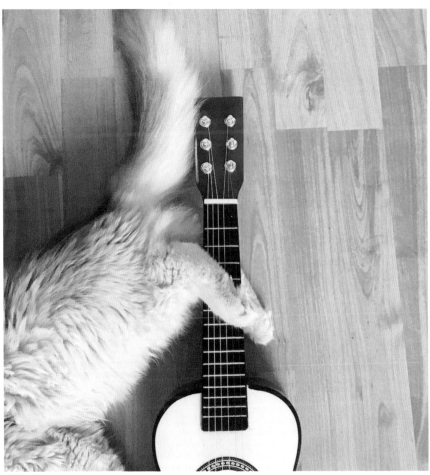

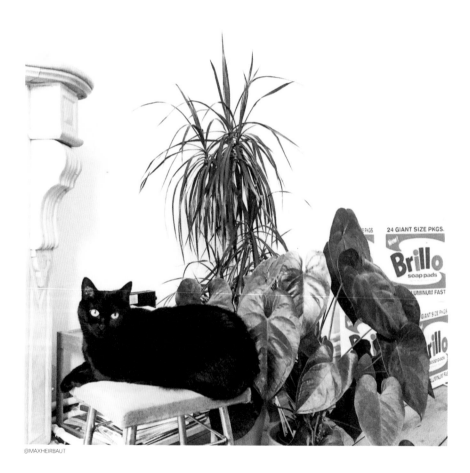

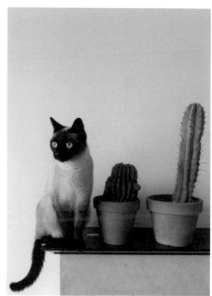

@BYAUDREYJEANNE

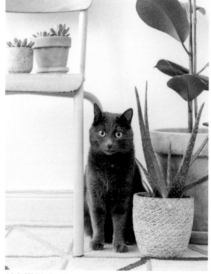

@CARNETDEPRINTEMPS

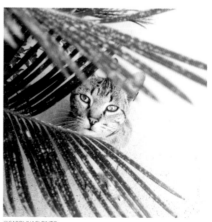

@CAROLINACLPINTO

"I HAVE LIVED WITH SEVERAL ZEN MASTERS. ALL OF THEM CATS."

ECKHART TOLLE

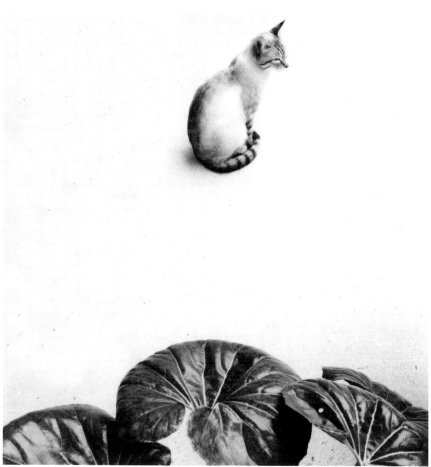

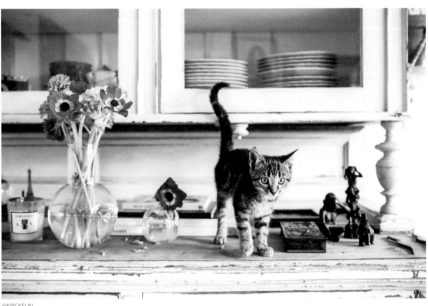

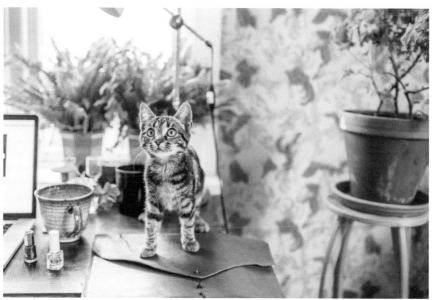

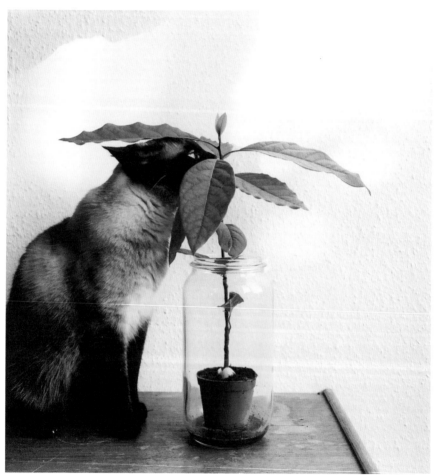

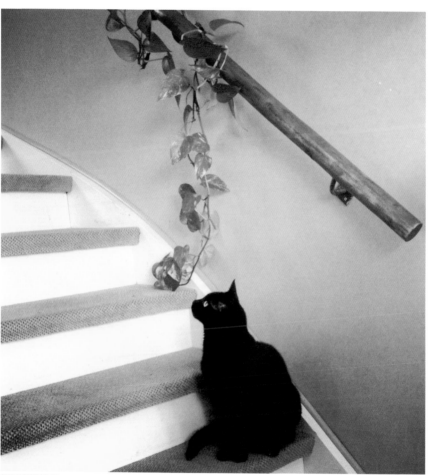

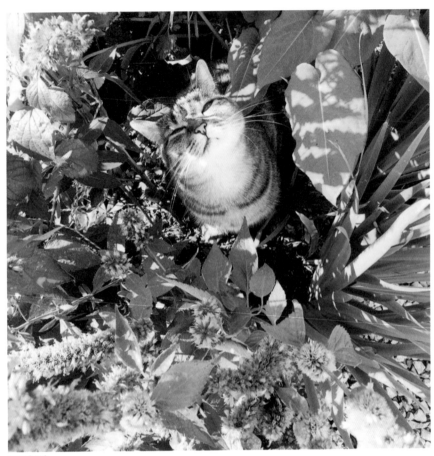

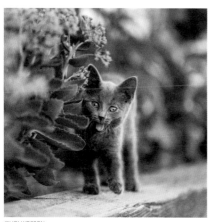

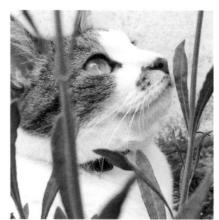

"MY CATS INSPIRE ME DAILY."

"THEY INSPIRE ME TO GET A DOG!"

GREG CURTIS

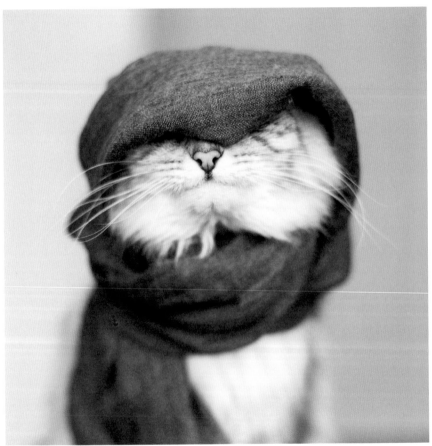

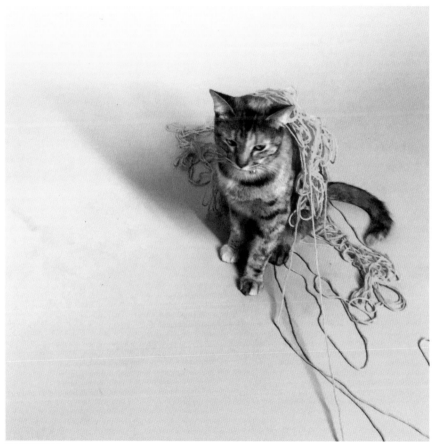

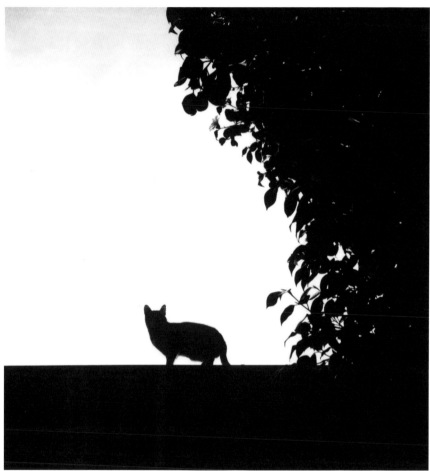

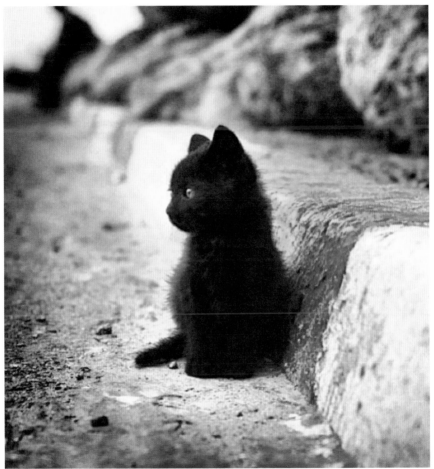

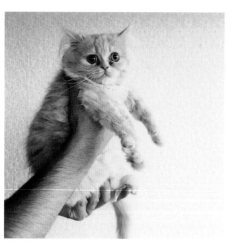

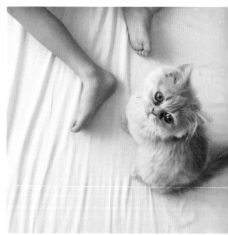

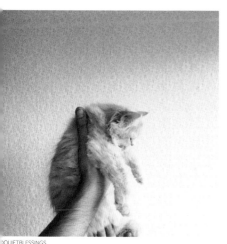

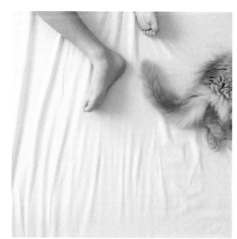

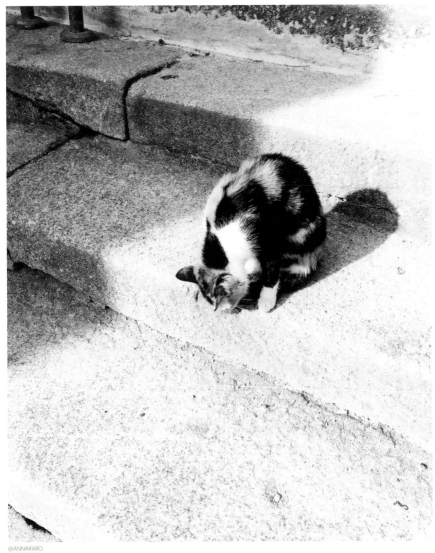

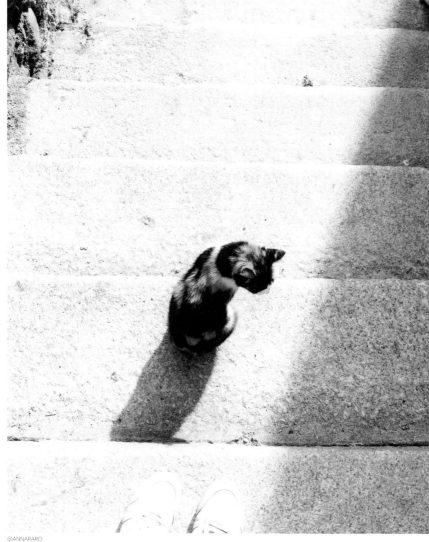

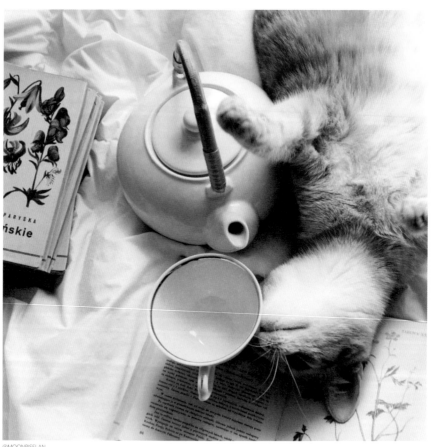

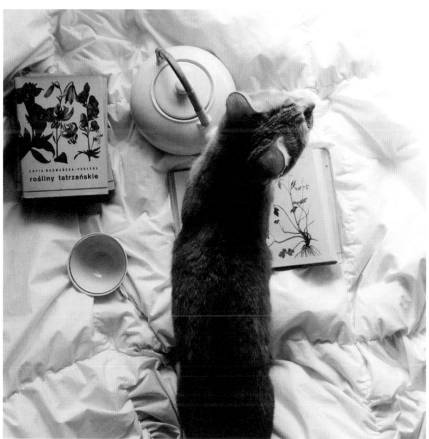

"IN MY HEAD, THE SKY IS BLUE, THE GRASS IS GREEN AND CATS ARE ORANGE."

JIM DAVIS

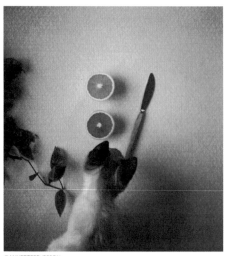
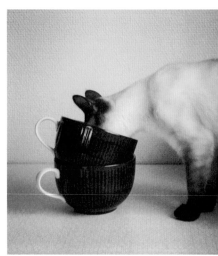

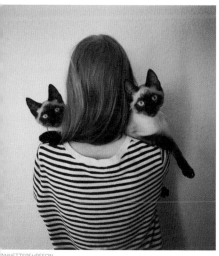

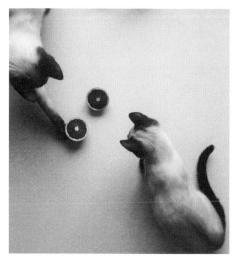

@KRICKELIN

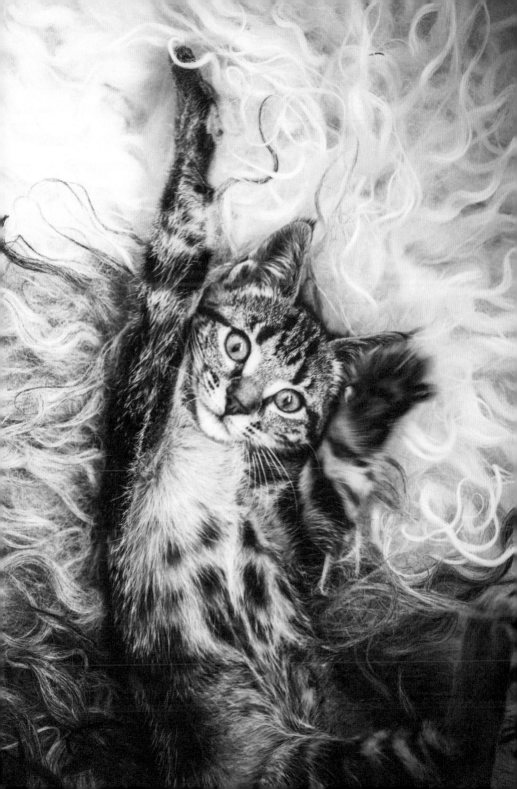

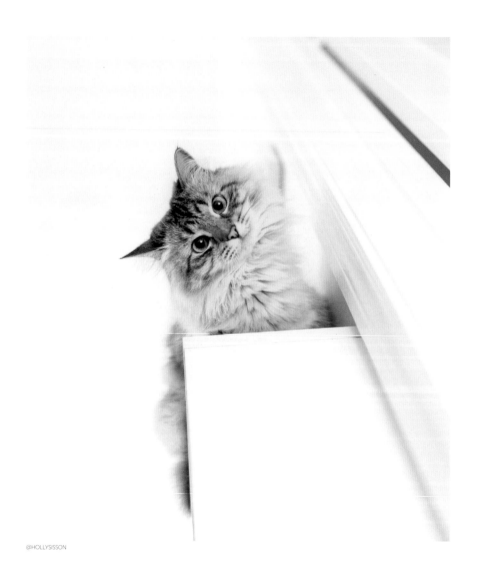

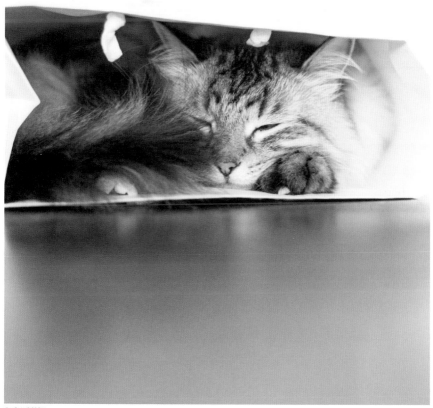

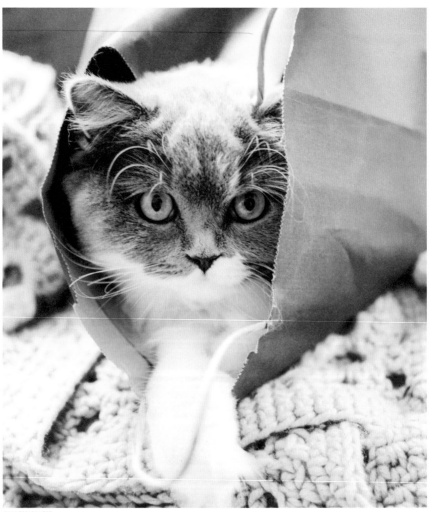

"CATS TELL ME WITHOUT EFFORT ALL THAT THERE IS TO KNOW."

CHARLES BUKOWSKI

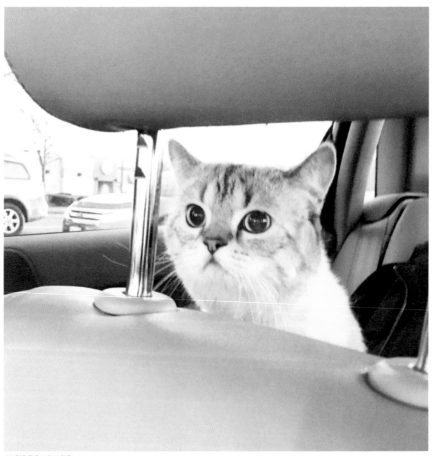

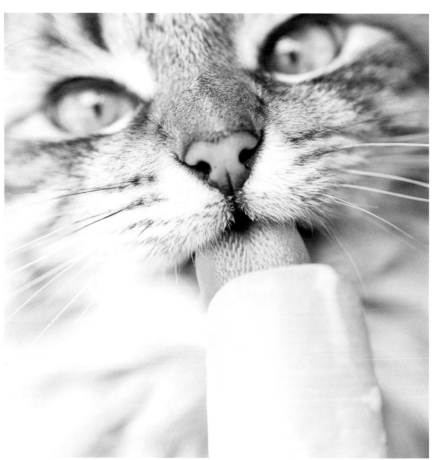

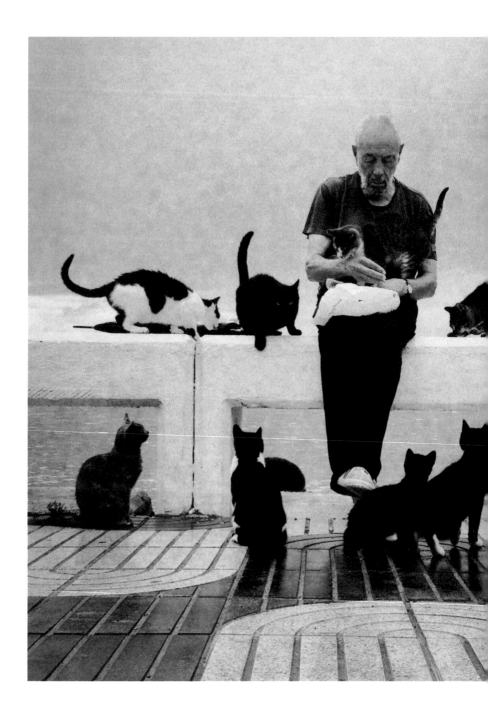

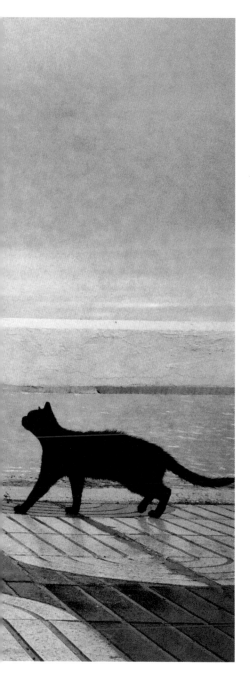

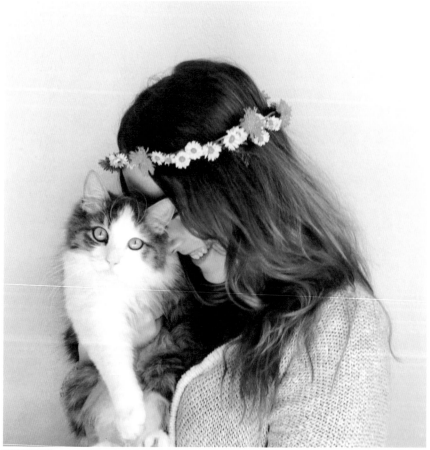

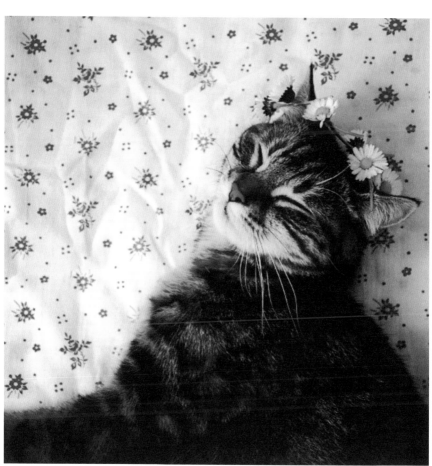

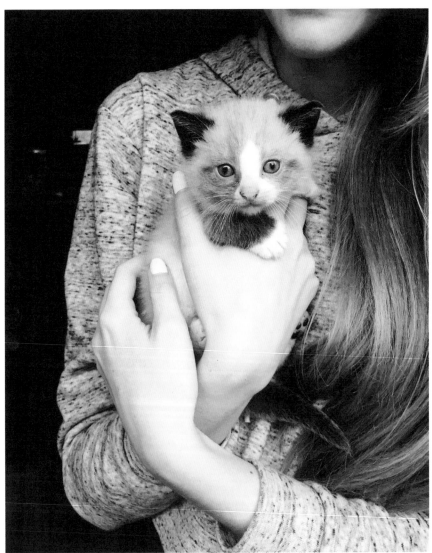

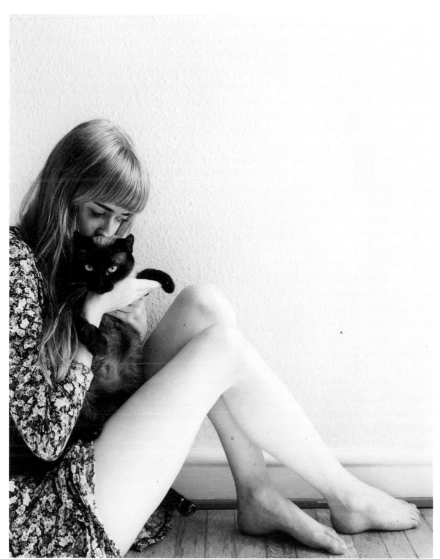

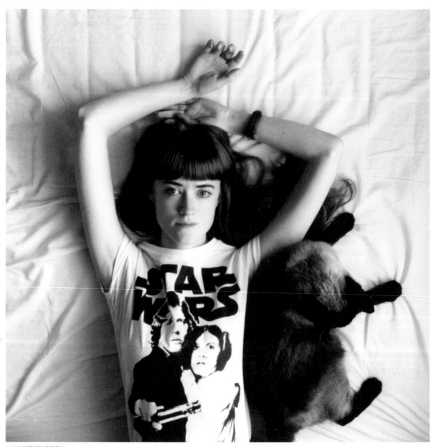

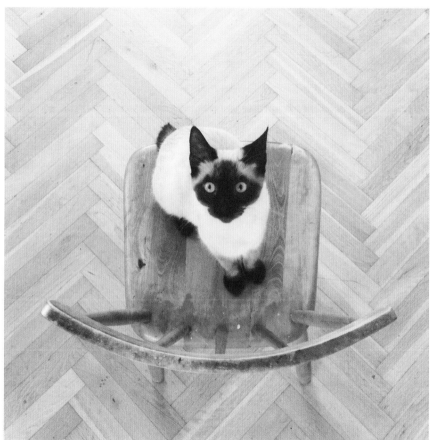

"I WOKE UP IN BED WITH A MAN AND A CAT. THE MAN WAS A STRANGER, THE CAT WAS NOT."

ROBERT A. HEINLEIN

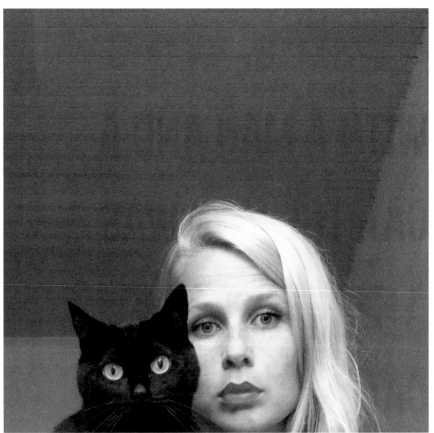

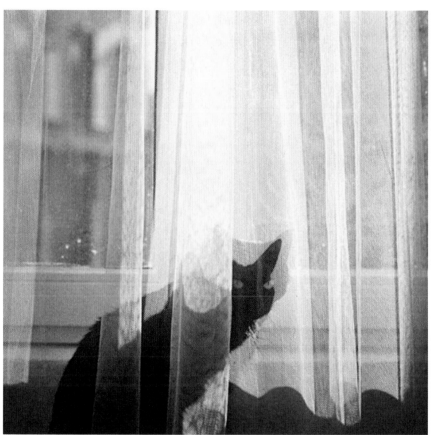

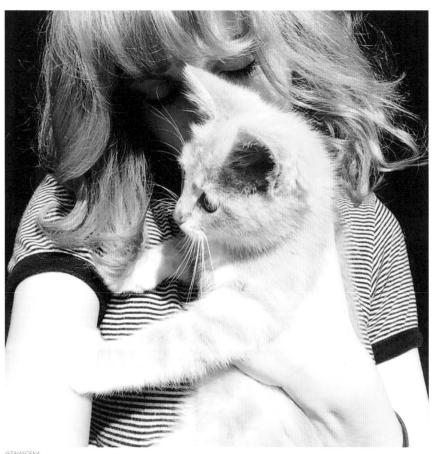
@TINASOSNA

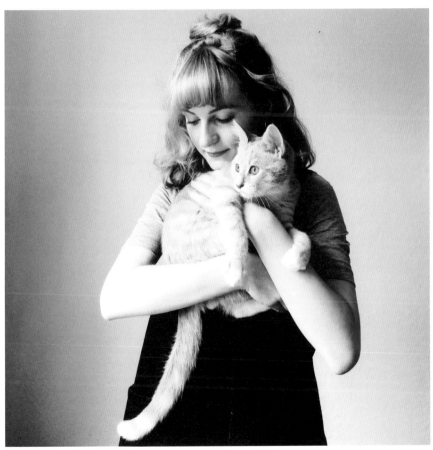

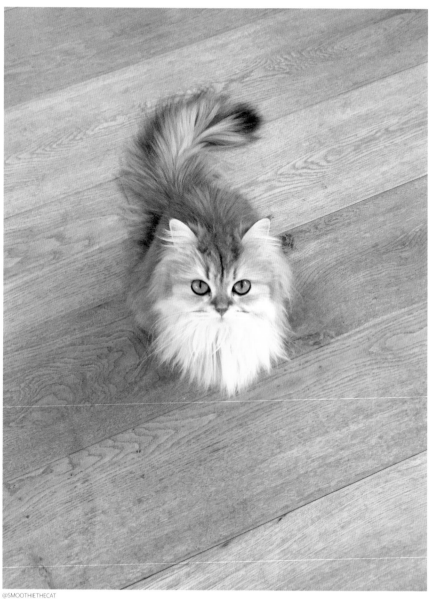

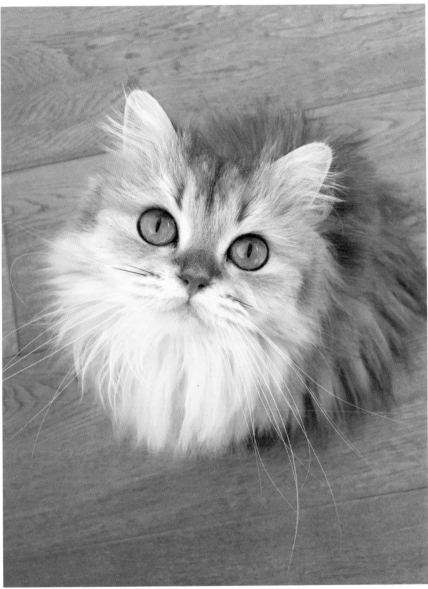

"THAT'S THE GREAT SECRET OF CREATIVITY. YOU TREAT IDEAS LIKE CATS: YOU MAKE THEM FOLLOW YOU."

RAY BRADBURY

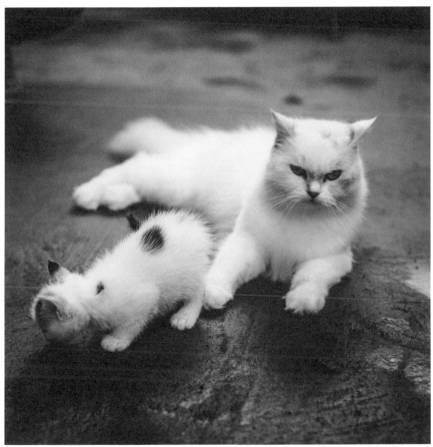

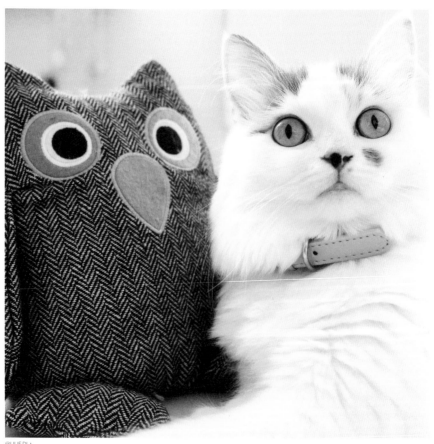

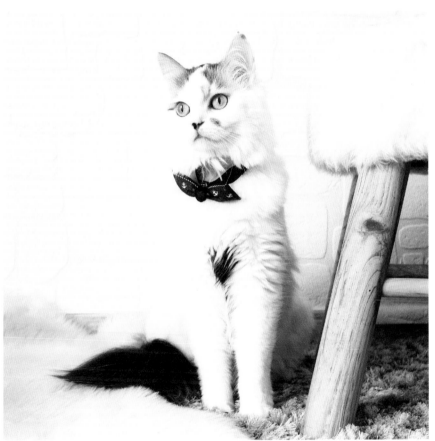

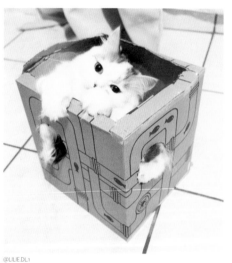

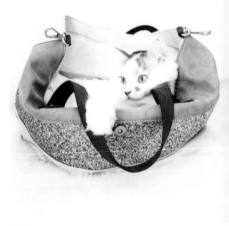

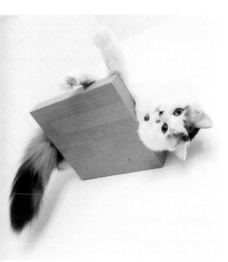

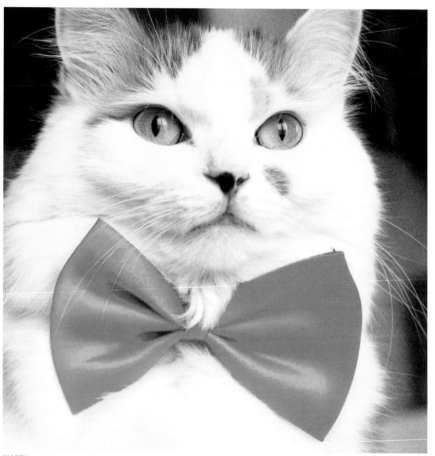

@LILIE.DL1

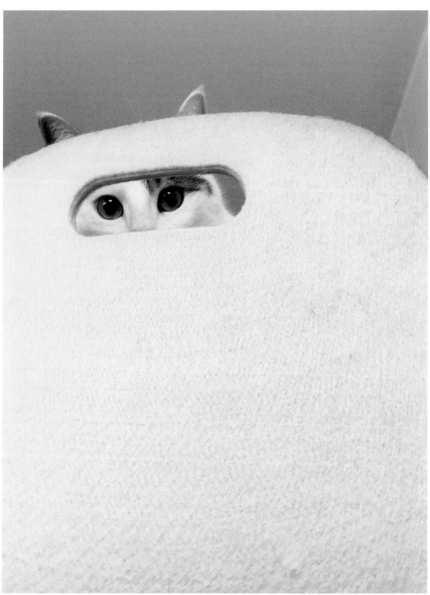

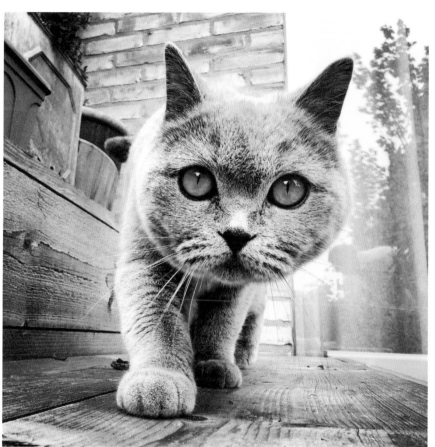

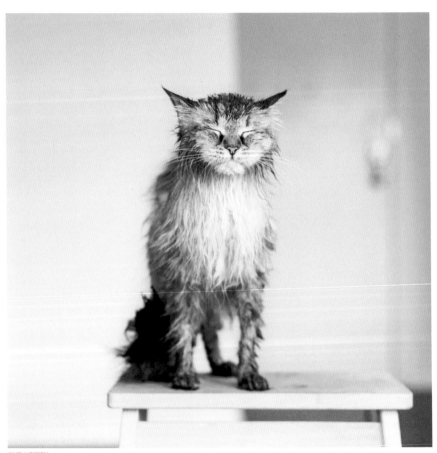

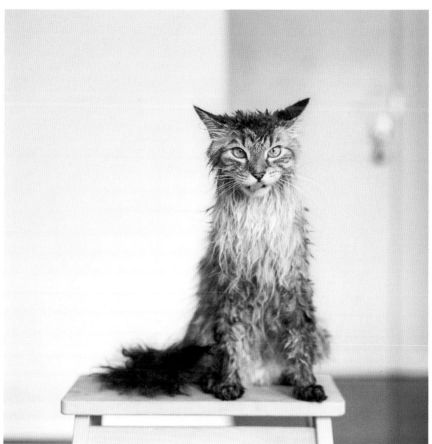

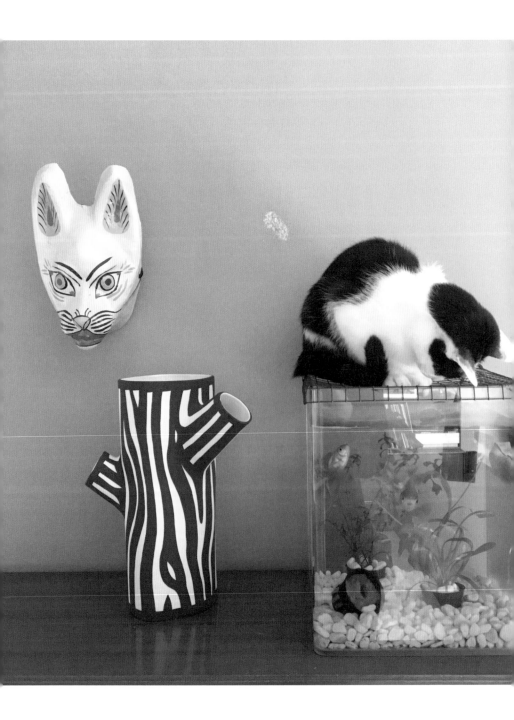

"CATS DON'T NEED TO BE POSSESSED. THEY'RE EVIL ON THEIR OWN."

PETER KREEFT

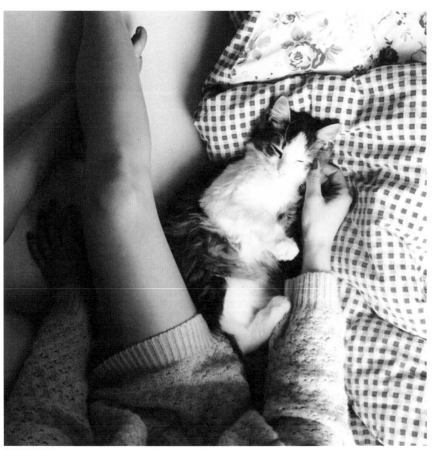

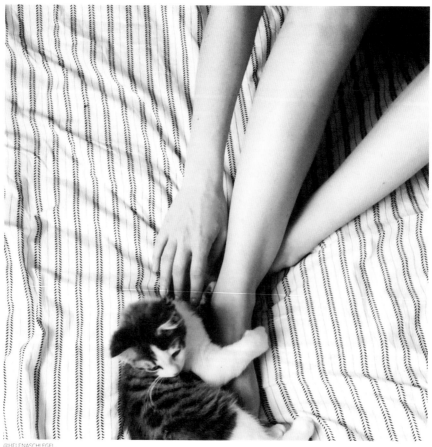

@HELENASCHLEGEL

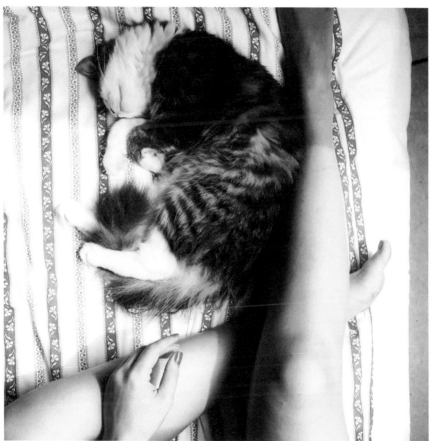

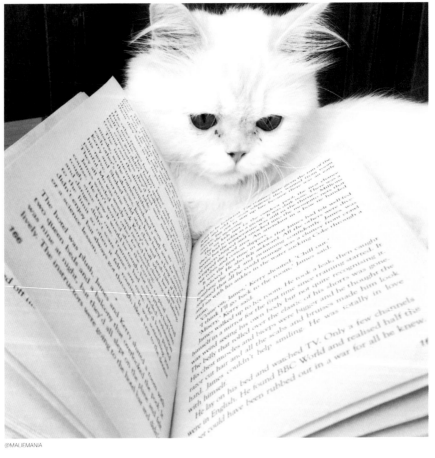

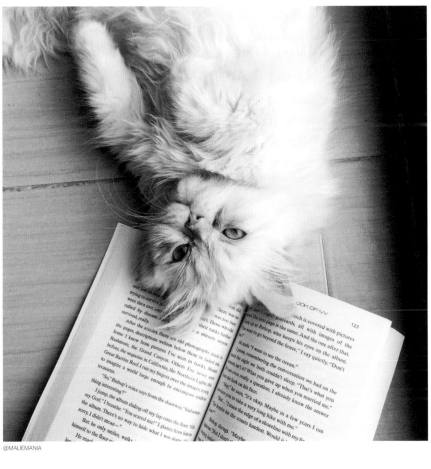

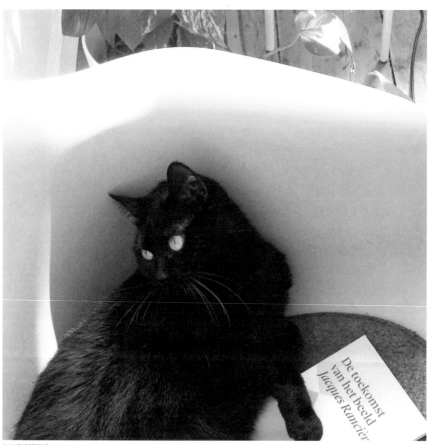

www.lannoo.com
Register on our website for our newsletter with
new publications as well as exclusive offers.

Photo Selection/Book Design:
Irene Schampaert

Cover image:
@millathecat

Also available:
Insta Grammar City
Insta Grammar Nordic

If you have any questions or remarks, please contact
our editorial team: redactiekunstenstijl@lannoo.com.

© Uitgeverij Lannoo nv, Tielt, 2016
D/2016/45/257 – NUR 652/653
ISBN 9789401436953